POSTCARD HISTORY SERIES

Kenosha

SIMMONS ISLAND. This aerial photograph, which was taken in the 1970s, shows Lake Michigan on the east, the island north of the harbor, and the Simmons factory to the south of the harbor entrance. The island was known as Washington Island until the 1930s, when Zalmon G. Simmons made a land trade of mutual benefit to Simmons and the city. The island was the location of early settlements. Situated with the Pike River at the north and Pike Creek at the south, both emptying into Lake Michigan, the picturesque area was the locale around which much of the historical development of the Kenosha area took place. (Courtesy of John Sullivan.)

On the front cover: **BUSY KENOSHA HARBOR.** From the early days to the present, Kenosha's harbor has been a very busy area.

On the back cover: **NIGHT VIEWS.** The evening photographs on this postcard, which was sponsored by the city of Kenosha Office of Public Information, were taken by Earlene Frederick, an outstanding photographer. We thank her for her generous contributions to this book.

POSTCARD HISTORY SERIES

Kenosha

John J. Hosmanek

Copyright © 2005 by John J. Hosmanek
ISBN 978-0-7385-4006-1

Published by Arcadia Publishing
Charleston SC, Chicago IL, Portsmouth NH, San Francisco CA

Printed in the United States of America

Library of Congress Catalog Card Number: 2005933525

For all general information contact Arcadia Publishing at:
Telephone 843-853-2070
Fax 843-853-0044
E-mail sales@arcadiapublishing.com
For customer service and orders:
Toll-Free 1-888-313-2665

Visit us on the Internet at www.arcadiapublishing.com

Contents

Acknowledgements 6

Introduction 7

1. Kenosha's Lakefront 9

2. Schools, Colleges, and Universities 23

3. Churches and Hospitals 41

4. Libraries and Parks 61

5. Civic Services, Events, and Organizations 75

6. Commerce and Industry 93

7. Retailers, Businesses, and Professions 113

ACKNOWLEDGMENTS

Quite early in my career as an administrator, I read a statement by Albert Einstein that struck me as being a succinct statement of philosophy: "Many times I realize how much my own success is built upon the labors of those with whom I work; and how earnestly I must exert myself in order to give in return as much as I have received."

Many people contributed to this book by helping locate postcards and photographs, or by letting me use their cards. Among them would be Arlene Billotti, John Bloner Jr., Art Buchanan, Carol Buzza, Kathy Cole, Rabbi Dena Feingold, Dave Fountain, Earlene Frederick, Ron Fredrickson, Tom Hosmanek, Fr. Stephen Hrycyniak, Steve Janiak, Santos Jimenez, Jack Kolar, Vern Kraus, Nancy and Sid Leonard, Dan Mack, Mary Ostermeyer, Ellen Pedraza, Peter Pingatore, Dick Regner, Bill Rice, Jason Rimkus, Vince Ruffolo, Judy Russow, Joseph Scuglik, John Sullivan, Steve Torcaso, Joan Turner, Ed Werner, and JoAnne Wolf. What a grand group of people.

In making acknowledgements, it is certainly appropriate to express gratitude to my late wife, Angeline, who was supportive in whatever I undertook, except for stock car racing. I also want to thank my daughter, Joan, who even though she knew I was busy enough, encouraged me to begin collecting local postcards, and she often assists me in looking for more cards at antique stores and flea markets. Thanks also to my son Tom, a fellow collector, who allowed me the use of his collection; Jane, who helps me on eBay; my son Mark and daughter Jean, who are always looking for cards I do not have yet.

Finally, thanks to those who purchase this book and thereby contribute to the Education Foundation of Kenosha and the Angeline Hosmanek Memorial Scholarship Fund.

Kenosha was my adopted community, for I was born some 25 miles further north. I liked the people of the community, and I stayed, even in retirement.

After you are retired and meeting friends, the often-repeated question is "What are you up to these days?" It may sound strange to some if the answer is that I am on the trail of vintage postcards, but I am.

INTRODUCTION

Long before the days of cellular phones or e-mail, the postcard served as a common mode of communication. A medium that was written and visual, private and public, postcards were an inexpensive way to communicate, especially during the early 1900s. The message was presented on both sides of the card. A meaningful photograph or illustration was featured on one side, and a handwritten message was included on the back, or sometimes on both sides. At one time, the post office forbade writing except in the prescribed area of the card. Postcards have become a treasured source of history, as they feature rare photographs, and at times, the cards recorded little bits of family and community history.

It is amazing that such historical treasures are kept in attics, boxes, and albums, stored away and sometimes forgotten. Local historians and history buffs feed on such materials, and it is fortunate that local history is not exclusively the province of professional historians. Local history is everyone's scholarly pursuit, from family history to organizational history to community history.

The local history contained on postcards and their messages complement or synthesize that which is contained in local newspapers, documents, photographs and books.

There is little to supplant the value of postcards in reminding townspeople of what the old high school building, known by many as "the Annex," looked like. Historic cards also help to conjure up recollections of what the sprawling Simmons Company area looked like prior to demolition of the plant and the development of the Harbor Park residential area. Indirectly, they are a reminder of how well government turns lemons into lemonade through the renewal of neighborhoods and commercial areas in the community.

Postcards are also a record of the huge transport ships involved in international trade that were common in the harbor not too many years ago; the importance of the railroads; the change that has taken place in retail business; and the importance of our schools, churches, libraries, hospitals, and medical facilities in our community.

Also recorded on postcards is the industrial era that some people labeled paternalistic, when the place where one worked sponsored baseball, basketball, soccer, and bowling teams, as well as a company marching band. Similarly, the transition from animal power to internal combustion engine power can be seen, as well as the evolution of automobiles and other modes of transportation.

"Ah, memories are made of this." Hopefully, this book will help readers recall pleasant memories of old Kenosha and serve as a conversation piece. Perhaps it will even entice readers to dig out those old cards that have been stored away.

One

Kenosha's Lakefront

Kenosha's history began at the lakefront, harbor, and Simmons Island area.

A preeminent Kenosha historian, Carrie Cropley, identified the island as one site of a Native American village. Present-day Kenosha was the site of villages in which the Potawatomi tribe, a part of the Algonquin nation, lived.

Prior to 1833, as Cropley relates, one of the villages was located on Simmons Island, and it was called Kenozia (pike) by Native Americans and trappers. Another village was located north of the present Chrysler plant in the Rice Park subdivision, and yet another was further south, near the lakeshore.

Pike Creek extended from the present harbor to the Washington Bowl and westward to the present-day Municipal Golf Course. Another branch, flowing from the area that is now Bradford High School, joined the Fiftieth Street branch at the golf course.

Wallace Mygatt, an early pioneer, stated that the chief Native American village was established north of what is now Fiftieth Street and west of Sheridan Road. He also wrote of the evidence of Native American homes on what is now Simmons Island.

In the 1830s, the government's doctrine of Manifest Destiny was accepted as the justification for pushing the Native Americans further westward, and in 1835, the prairie wilderness on the southwestern shores of Lake Michigan was settled and named Pike, but soon after it was renamed Southport.

Although some early settlers came over land, most came to this area by way of the Great Lakes. Either method of travel in the early to mid-1800s was hazardous and difficult.

Only the speculation for land and the desire for independence and adventure prevailed over the concern for one's safety and well-being.

Col. Michael Frank's recording regarding the settlement of this area is based on the accounts he heard from the actual participants. It begins with the dinner meeting in Hannibal, New York, in December 1834 to discuss settlement in the West. Frank described the formation of an emigration company. At a subsequent meeting, held in February 1835, the organization was perfected under the name of the Western Emigration Company.

By the spring of 1835, the company appointed a small advance party to explore the little-known regions on the western shores of Lake Michigan.

MICHAEL FRANK. A genuine moral and political leader, Michael Frank was the first Southport Village president, first mayor of Kenosha, territorial representative, and school superintendent and editor of the *Southport Telegraph*. He earned the title, "father of the free public schools in Wisconsin." (Courtesy of the Kenosha School District Archives.)

HARBOR ENTRANCE VIEW. The old North Pier had a catwalk that enabled the lighthouse keeper to replenish the kerosene fueling the light at the harbor entrance during all kinds of weather. Shown to the left is the old harbor light. (Author's collection.)

THE 1866 LIGHT STATION. Rising above the island is the 1866 lighthouse, which was built on the foundation of an earlier lighthouse. Next to the lighthouse stands the keeper's dwelling, which was built in 1867. The card was postmarked in 1910. (Author's collection.)

THE 1866 LIGHT STATION AND GROUNDS. Although the lighthouse has not changed much, the grounds show changes in the harbor area. The writer of the above card details the surprise shown by relatives in Kenosha who had not yet received a letter telling of her plan to visit them. She wrote, "No one at the depot to meet me. Were all out on the pier fishing..." Such details and even amorous sentiments were frequently written on post cards. (Author's collection.)

HARBOR VIEW. Even longtime Kenosha residents have difficulty with the perspective of this pre-1911 view. The photograph looks northward from the bridge, which curved from a slanted northwesterly to northerly position on the channel that ran east and south of the Allen Tannery. The tannery was located about where the municipal building is now, but it extends a block north and west. Later, after Pike Creek was filled in, the Sixth Avenue Bridge was built further south and west. (Author's collection.)

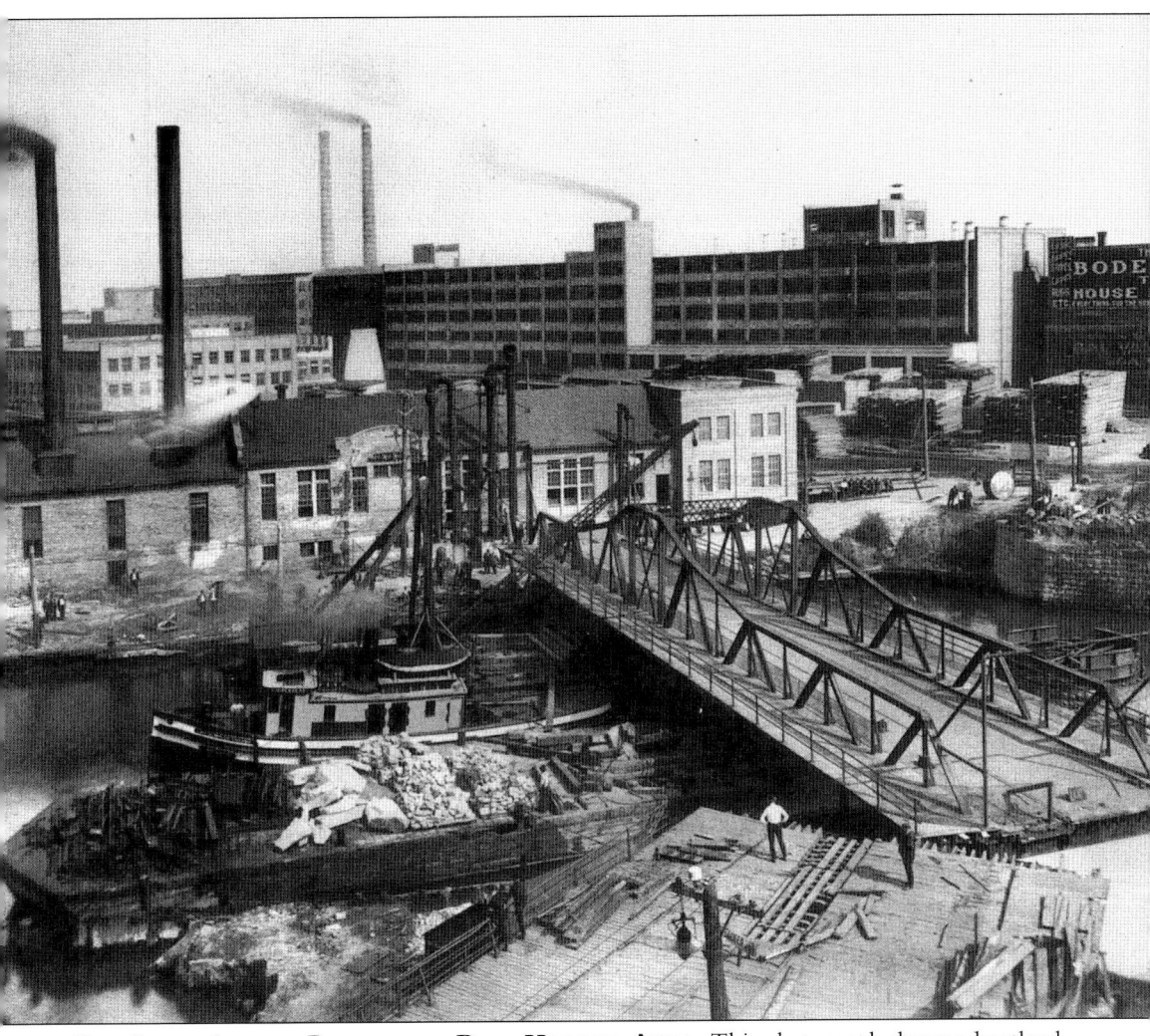

OLD SIXTH AVENUE BRIDGE AND BUSY HARBOR AREA. This photograph shows a boatload of bark, that was used for tanning hides, going under the turning bridge to the Allen Tannery. Simmons Company buildings can be seen in the background, and the Bode Furniture Store, located on the east of today's Sixth Avenue, is south of the bridge. (Courtesy of Vince Ruffolo.)

JACOBS ISLAND. The Pike River flows south past Carthage College on the east and St. George Cemetery on the west. It then turns to the east and empties into Lake Michigan, just east of where Seventh Avenue crosses Sheridan Road. Jacobs Island was located midway between Carthage and where the river empties into the lake. It was known as Second Island, and Simmons Island was known as First Island. At one time, much of the area was marshland. (Author's collection.)

PIKE RIVER. This historic waterway is a pleasant recreational area. Taken in the early 1940s, this postcard shows a small portion of the picturesque Pike River. As more care has been given to the river and to environmental concerns, the river overflowing its banks is becoming far less a problem than in the past. A swift current and undertow at the area where the water enters Lake Michigan has been a treacherous attraction for swimmers for decades. (Author's collection.)

THE MIDDLE STREET BRIDGE. Since 1927, Middle Street has been known as Fiftieth Street, and a bridge still spans the river here. This photograph was taken around 1907 from the Simmons Island side of the harbor inlet, looking toward the west. This channel has been deepened and widened considerably to accommodate the boat traffic going to the small boat marina located at the north end of Simmons Island. (Author's collection.)

THE FIFTIETH STREET BRIDGE. Seen in the background of this postcard is the huge Simmons Mattress Company. The house on the left was located on Washington Island (Simmons Island). After dredging and the improvement of the creek banks, this area is now a part of the Simmons Island Small Boat Marina. (Author's collection.)

VIEW FROM WASHINGTON ISLAND. Postmarked in 1907, this card shows the undeveloped Pike Creek area that is today a splendid small boat marina. Washington Island was renamed Simmons Island after the heirs of Z. G. Simmons turned over all of their property on the island to the city of Kenosha in exchange for vacating some street endings. Although mutually beneficial, the city gained much more in the deal and graciously renamed the island. (Author's collection.)

SIMMONS ISLAND MARINA. Looking north from the Fiftieth Street Bridge, this recent postcard shows the well-developed small boat marina. The island can be seen on the right. This location provides easy boat access to Lake Michigan through the Kenosha harbor. (Author's collection; courtesy of Timm Bundies.)

HARBOR AREA, LOOKING SOUTH. The Simmons Company buildings can be seen in the background of this postcard. The Morgan's Club House, seen on the right, was a private enterprise. During the days of the "noble experiment," Prohibition, Kenosha did its share of experimenting, and in 1932, a raid by federal agents discovered 3,500 gallons of beer at the Morgan Club House and nearby barn. Additional raids produced sufficient evidence of the violation of the order against making or selling alcoholic beverages by various roadhouses and taverns. (Author's collection.)

LIFEBOAT STATION. On this site in 1879, the federal lifeboat service built a facility to store lifeboats and house seven surfmen and the keeper heading the operation. Today, this is the site of the United States Coast Guard Station that was formed by the merger of the United States Life-Saving Service and United States Revenue Cutter Service. The men were assigned lookout duty on two-hour shifts and patrolled the waterfront watching for problems or distress signals from boats. (Author's collection.)

NEW LIFESAVING STATION. In 1907, the federal government allocated funding for a new and enlarged lifesaving service facility. The federal regulations also improved the pay of the men engaged in lifesaving, and it established an equitable and regular system to give the men some time with their families each week. The Kenosha crew was headed by Benjamin Cameron, and the crew had regular training sessions and periodic inspections by officers of the federal service. (Author's collection.)

LIFESAVING CREW. The Lifesaving Crew was a federal government program, and except for several winter months, the seven-member crew and the keeper watched activity on the lake and in the harbor area. Regular rescues and retrieval of drowned seamen and occasionally swimmers occupied the men who patrolled the lakeshore. (Courtesy of Tom Hosmanek.)

UNITED STATES COAST GUARD, KENOSHA STATION. Established in 1879 as a station of the United States Life-Saving Service, many lives were saved in and around the Kenosha Harbor by the seven-man crew assigned to the local station. The service was combined with the United States Revenue Cutter Service and other governmental services to form the United States Coast Guard in 1915. In the inset is a photograph of Capt. Benjamin J. Cameron, a hero who saved more than 500 people in his lifetime and career of more than 30 years. (Author's collection; courtesy of Edward Werner.)

LIFESAVING DRILL. Interested Kenosha residents often gathered on shore to witness the livesavers' drills. During these drills, the crew overturned the skiff deliberately and returned it to the upright position, within a minute. They then continued on with the drill to the cheers of the crowd on shore. (Courtesy of Sid Leonard.)

A CREW OF SEVEN. This postcard was mailed in Kenosha in 1907. It shows a crew of seven men and boys. Sailing in the early 20th century was often dangerous, and without a radio, the only tool crews had to call for help was a distress signal with a flag that might be seen from shore. The Lifesaving Crew's responsibility was to watch for such signals, although they also saved many intrepid youngsters who ventured too far on rafts, skiffs, and other floating vessels. (Author's collection.)

BIG SHIPS. Following the opening of the St. Lawrence Seaway, Kenosha became a fairly busy seaport. Coupled with the local automobile industry and the importing of foreign-made automobiles, frequently there were three or four foreign ships in the harbor area loading and unloading cargo. American ships, as well as those from Denmark, France, Germany, and the Soviet Union were frequent visitors. (Author's collection.)

SHIPPING LANE. At times, there were as many as five large ships in the harbor. Large harbors, such as Milwaukee's, which was located just 35 miles north, and Chicago's, which was only 50 miles to the south, gradually edged out Kenosha shipping. (Author's collection.)

SIXTH STREET BRIDGE. The relocation of the creek bed and bridge permitted the straightening of Sixth Avenue. Some decades later, a colorful mayor, carried away in his rhetoric, is reported to have declared, "I'll jump off the Sixth Bridge before I would raise taxes." Reportedly, in the next month taxes were raised, and the bridge was closed for rebuilding. (Author's collection.)

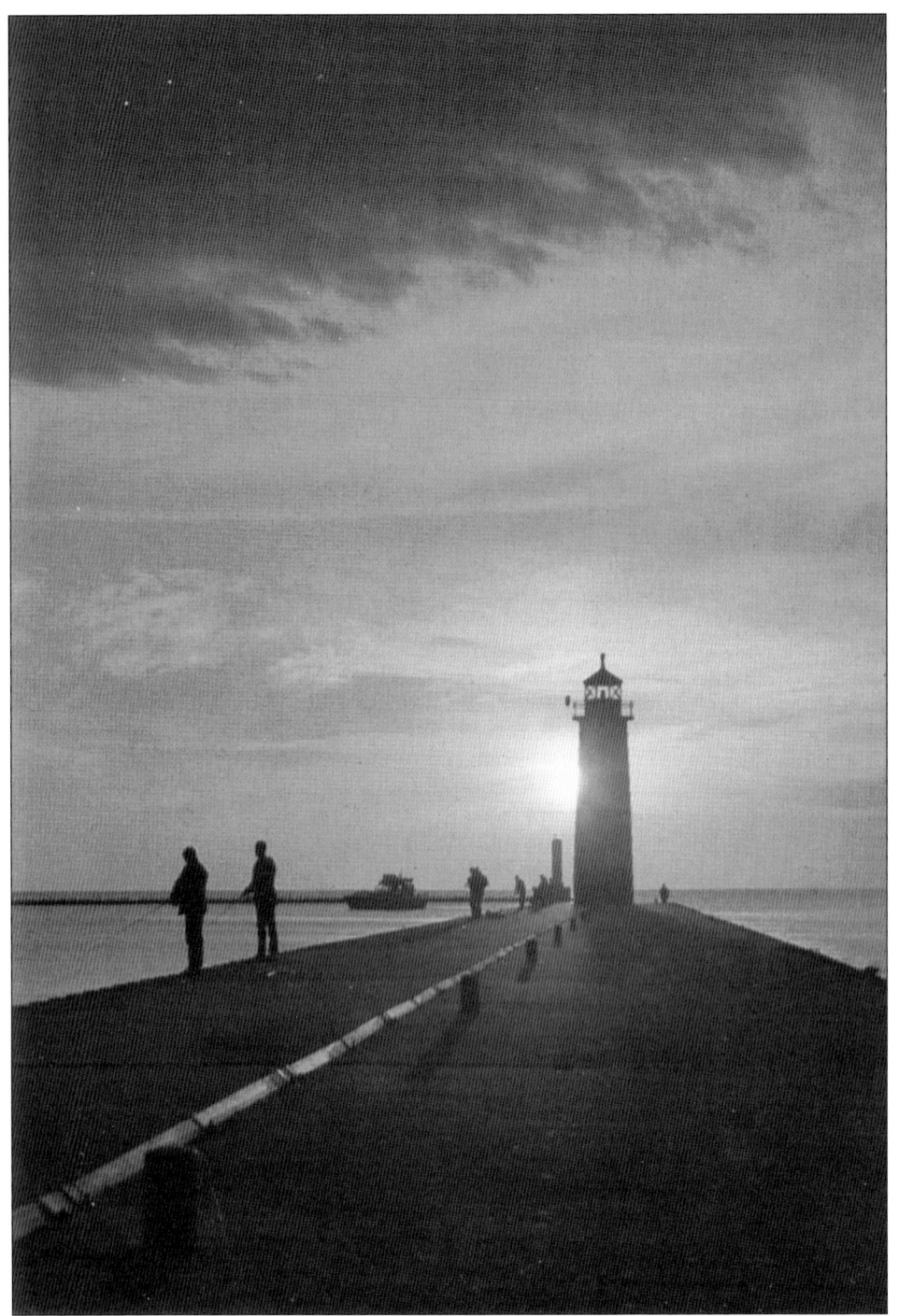

EARLY MORNING FISHING. The fishing is frequently very good on Kenosha's two piers located along the harbor entrance. The number of fishermen increases quickly when the fishing is good. Perch are not as plentiful as when it was customary to "pull up double-headers," but the variety is greater and includes coho salmon, lake trout, bass, and other varieties in addition to perch. (Courtesy of Timm Bundies.)

Two

Schools, Colleges, and Universities

Under the laws passed in 1839 governing the school districts of the Wisconsin Territorial legislature, local school districts were created, but they were not required to do anything. In reality, all that was done was that the school districts at that time sanctioned schools classified as tuition or select schools for those whose parents could afford to pay for their education. These were the first established schools in Southport.

One of the major leaders in the territorial legislature's movement for the government to provide free public schools was Michael Frank. He was a man of character who had a reputation for declaring his strong beliefs in a rational, dignified manner. He favored temperance, abolition of slavery, respect for the beliefs of others, and free public schools.

Frank introduced a measure to authorize the voters of Southport to vote for sufficient taxes, not to exceed $2,000, on all the assessed property to help support the schools in the town.

His earnestness, persuasive powers, and indomitable courage overcame opposition to the new bill. The first meeting to consider the measure was held in Southport on March 24, 1845, and it broke up in confusion.

At the meeting, an opponent of the law vehemently declared, "What? I be taxed for the education of the damned Dutch and Irish! Never!"

Rev. Reuben Deming responded, "Yes, an education for all children would help in making them, let us hope, better citizens than you and I are."

A local newspaper, the *Southport American*, pointed out that some states established schools for paupers, and it quoted Episcopal bishop G. W. Doane, "We utterly repudiate as unworthy, not of freemen only, but of men, the narrow notion that where is there is to be an education for the poor as such. Has God provided for the poor a coarser earth, a thinner air, a paler sky?"

Public meetings were held at the Methodist church, and editor C. L. Sholes of the *Southport Telegraph* urged attendance at those meetings. Finally, at a meeting held to close the campaign, a victorious 90 to 79 vote was recorded.

The first classes of the free public school were held in the basement of the Catholic church on June 18, 1845. An entry in Michael Frank's diary revealed his pleasant visit to a free school Christmas program six months after the initiation of the free school. He wrote, "In the evening attended a school celebration in the basement of the Catholic Church. . . . Among the speeches one by myself. Have never attended anything in the territory which gave me more satisfaction."

FIRST FREE PUBLIC SCHOOL. This building was constructed in Southport in 1849, as the "first free public school outside of New England in the Union." (Courtesy of the Kenosha School District archives.)

DURKEE SCHOOL. After Kenosha outgrew the first elementary school that had been built in back of the 1849 school, the school board asked the widow of Sen. Charles Durkee to change the $5,000 bequest he had made to furnish a telescope to the schools, and to build a new school. That 1877 school was named in his honor. Shown on the postcard, above, is the second Charles Durkee School. It was constructed on the site of the first and was built in 1905. It was built after numerous other alternatives for housing the rapidly growing numbers of pupils were considered. More school classrooms were needed even as this new school was occupied. This school was considerably larger than the first Durkee School and cost $41,000. (Author's collection.)

KENOSHA PUBLIC SCHOOL WEEKLY REPORT. In 1855, scholars in the public schools received a weekly report on their achievements and progress. Items such as this and numerous other kinds of certificates, diplomas, and teacher certifications have been collected and are kept at the Kenosha School District archives at the Educational Support Center. Despite the fact that for most of its existence, the school district did not have sufficient classrooms to adequately house the numbers of students, the district has maintained high standards, a well-qualified staff, and above state average achievement levels. (Courtesy of the Kenosha School District archives.)

FRANK SCHOOL BELL. The new Michael Frank School was given a large bell by the fire department. The bell hung in the Durant Foundry in Kenosha during the 1860s and then in the old fire department engine house No. 1. Many school bells were lost during hard times when a school bell was often used as payment for roofing. (Author's collection.)

FRANK SCHOOL, 1895. In December 1895, the new Michael Frank School was opened. It consisted of four spacious rooms. Within two years four more rooms were added. Eva Riley was appointed principal, which marked the first woman principal in the Kenosha schools. The school has been enlarged and renovated in recent years. (Author's collection.)

SECOND WARD SCHOOL. After Kenosha School District No. 1 was organized, this school, which was built as a private rate school, was purchased by the district. It was replaced by the Weiskopf School, and the old building was sold in 1902 for $400 and moved to Caledonia and Quince Streets (now Sheridan Road and Forty-seventh Street). Today, it stands as a bar and drive-through liquor store. (Courtesy of the Kenosha School District archives.)

NEW HIGH SCHOOL, 1890. When it came time to demolish the first high school building, there was much anguish expressed by citizens who did not want to see their school demolished. In 1980, a similar emotional outcry occurred as this high school, then affectionately called "the Annex," was demolished. The 1890 high school was poorly constructed with a slate roof that was too heavy to be supported by the foundation and wall structure. It was deemed unsafe by fire officials for many years. (Author's collection.)

THE ANNEX. After the new high school was built just to the east, the old 1890 building became Central Junior High School, but after several years, it became an annex to the main building. Fire officials cited the additional walls built to reinforce the stately building as flues. More federal funds were spent on renovations in the 1930s than the original structure had cost. The tower was removed in 1921 because it was deemed too dangerous to leave it on the building. The bell was saved and is displayed in a case in the Bradford High School auditorium lobby. (Author's collection.)

WEISKOPF SCHOOL. The second ward had become the sixth ward by the time that a fine eight-classroom building was constructed in February 1903. The new building featured a principal's office, teachers' "retiring" room, a large recitation room, and an attic auditorium. The school board had to choose whom to name the school after. The two choices were John McMynn, a former principal of Kenosha High School and state superintendent, and Dr. Anton Weiskopf, a very supportive physician who lived across the street from the school. The board chose to name the new $22,090 school in honor of Weiskopf. (Author's collection.)

GILLETT SCHOOL. After a "ward battle" among the three north side wards, a lot was purchased for a new school at the corner of Sheridan Road and Forty-third Street near the south end of the Washington Middle School grounds. A former school board member, Hon. Gurdin Gillett, died in June 1899, and the school board quickly closed the schools for a half day and named the new school in his honor. The large four-room building served several grades and eventually served handicapped youngsters. It was demolished in 1920. (Author's collection.)

BAIN SCHOOL. Until the mid-1960s, Kenosha's schools were under the governance of a school board, but the funding was controlled by the city council or city manager. Obtaining the necessary funding was always difficult, and from the early 1900s to the 1980s, the schools were greatly overcrowded. It took several years to get the property and funding to build Bain School in 1910. When built, it was located on the Bain family property in Somers Township, the former home of the county fairgrounds. A new Bain School of Languages was built nearby and dedicated in 2004. (Author's collection.)

COLUMBUS SCHOOL. The opening of Columbus School took place following the spring recess in 1911, with 544 pupils filling the 12 classrooms. Marie Keating was appointed as the principal at a salary of $1,100 a year. At that point, all pupils in the school district were in regular classrooms and no basement rooms were used for academic classrooms. As the opening took place, it was announced that a 32-inch bell was purchased for installation at the school, and the purchase of a statue of Columbus was planned for later. (Courtesy of Tom Hosmanek.)

KENOSHA CENTRAL HIGH SCHOOL, 1926. The new high school was built as part of the civic square, for which the city of Kenosha was recognized in 1925 as the leading community in the state for planning growth. A block-wide park in the center was bordered by the high school on the south, county courthouse on the north, the post office and city hall on the east, and the city museum on the west. This building was constructed less than a block away from the 1849 school. (Author's collection.)

KENOSHA CENTRAL BECOMES BRADFORD. In 1940, a group of alumni began a drive to rename the high school in honor of Michael Frank. That effort faltered, and the name of a former superintendent, Mary D. Bradford, was then proposed. The board adopted the Bradford name in 1941, but it took several years to be used regularly. When Bradford High School moved to new quarters on Thirty-ninth Street and Washington Road in 1980, the faculty voted to take the name for the new high school. The old building then became Reuther Alternative High. (Author's collection.)

MARY D. BRADFORD HIGH SCHOOL BAND - KENOSHA, WISCONSIN - 1964

HIGH SCHOOL BAND. Kenosha is a musical town and has consistently produced outstanding musical organizations. Ralph Houghton came to Kenosha in the late 1950s and did much to enhance the level of musicianship in the schools. He served as director of music and later as the assistant superintendent of schools. Bradford High School has records in all areas of learning extending back to the 1800s. Numerous outstanding alumni include Dan Travanty, Alan Ameche, Lloyd Ogilvie, Phil Sander, and Al Molinaro. The Mary D. Bradford High School is one of two traditional comprehensive high schools in Kenosha. Bradford has an outstanding record in academics, the arts, and other areas. After the failure of a series of referendums to build a new high school, and following much political activity, the Kenosha Unified School District purchased the old University of Wisconsin Kenosha Extension Building from the city and county. The new school was built around the university building in 1980 at a cost exceeding $11 million. (Courtesy of Dan Mack.)

CHAMPIONS. George Nelson Tremper High School athletic teams have taken more than their share of regional and state championships. Outstanding coaches have included Charles Bradley, Pete Johnson, Les Holman, Santos Jimenez, Glenn McCulloch, and Ron Davies. Davies has several state championships to his credit including back-to-back state football championships. Shown is the 1985–1986 basketball team coached by Santos Jimenez. Tremper has also consistently excelled in many academic, music, and art competitions. The high school building has two two-story academic wings, an auditorium, gymnasium, and swimming pool in addition to administrative and guidance offices. It cost about $5 million in 1965. While the school was being built, high school students attended classes and activities on a double-shift basis for several years at the old Bradford High School, now the Walter Reuther High School. (Author's collection.)

WASHINGTON JUNIOR HIGH SCHOOL. Washington School was initially called a community center when it opened in 1920. The auditorium was used for many high school events, while the old 1890 high school (later, the Annex) auditorium/study hall was deemed unsafe for large groups. This school had the first school public-address system, which was planned and wired by principal James Chapel, a former high school science teacher. Washington and McKinley Junior High Schools were built using the same construction plans. (Author's collection.)

MCKINLEY JUNIOR HIGH SCHOOL. Although the same architectural plan as that used for Washington was to be used for McKinley Junior High School, political wrangling, sewer installation, and soil conditions delayed the construction of McKinley. The school was organized as a junior high school after Lincoln and Washington. All five junior high schools are now used as middle schools in Kenosha. (Author's collection.)

LINCOLN JUNIOR HIGH. Kenosha was among the earliest school districts to see possibilities in the junior high school concept for dealing not only with extending the education of children beyond eighth grade, but also solving some of the overcrowding in local schools. The valid educational justifications were seen as the concept was implemented. (Courtesy of Tom Hosmanek.)

KEMPER HALL. Initially established as St. Clare's Episcopal Seminary, Kemper Hall developed into a school for girls. Charles Durkee donated his home on the lakefront to be used for the school on the condition that his widow was paid an annuity for the remainder of her life. In 1878, the school was placed in charge of the Sisters of St. Mary of New York, under the auspices of the Episcopal church. In 1883, a local newspaper described the school as "High Church Episcopal." At that time, there were 10 nuns teaching about 50 girls, and none were from Kenosha. (Author's collection.)

ST. JOSEPH HIGH SCHOOL. As schools opened in 1957, there were 10,427 students enrolled in the public schools. Another 4,200 students were enrolled in the nine Catholic and two Lutheran schools in the city, and an additional 400 students were enrolled at the new St. Joseph Catholic High School. Although St. Joseph High School alleviated the overcrowding at the public high schools, the high numbers of students worried city and school officials. In the 1960s, enrollments in all schools continued to increase. (Author's collection.)

ST. GEORGE SCHOOL. Parochial schools have played in important role in the education of Kenosha's youngsters from the early days. For a while after the Civil War and into the 1920s, there was some bigotry among earlier immigrants toward the later groups, and both the parochial and public schools worked to help children who were foreign-born or whose parents were foreign-born get acclimated. St. George Catholic School and Friedens Lutheran School were located a block apart and cooperated in housing pupils when the need arose. (Author's collection.)

KENOSHA GRAND CONSERVATORY OF MUSIC. Music has always been important to the residents of Kenosha. As early as 1907, a small orchestra was started at the high school and choral groups performed in the area. The grand conservatory shown on this postcard was located in a home that still exists on Sixty-first Street, south of Library Square. The conservatory advertised that it provided a full course leading to the degree of bachelor of music and that instruction was "under University Supervision." (Author's collection.)

TRENARY COLLEGE OF COMMERCE. Many prominent residents, including former mayor Eugene Hammond, were graduates of the Trenary College of Commerce. For most of its existence, the school was located in these quarters on Sheridan Road across from the courthouse. After retiring, Otis Trenary leased and then sold the building to the public school district, and 5515 Sheridan Road became the home of the school administration offices during the late 1950s. (Courtesy of Tom Hosmanek.)

CARTHAGE COLLEGE. In 1956, a news item about an Illinois college wanting to relocate its campus appeared in the *Kenosha News* and other newspapers. The item attracted a number of local civic leaders who seemed to realize the value of having Carthage College, a liberal arts college, relocate to Kenosha. After persuading the Carthage officials and overcoming some local reluctance to give up park land for the college, the big move took place. (Courtesy of S. Janiak, Carthage College.)

CARTHAGE COLLEGE CHAPEL AND ARTS CENTER. As Carthage developed into the beautiful campus on the lakeshore at the northern end of Kenosha, some striking structures were added. Shown here at night, are the H. F. Johnson Arts Center and the A. F. Siebert Chapel. Since relocating to Kenosha, Carthage College has become an outstanding community asset, providing excellent educational opportunities. The college is affiliated with the Evangelical Lutheran Church in America. (Author's collection; courtesy of June Kuefler.)

CARTHAGE ON THE LAKE. Beautiful views of Lake Michigan distinguish the Carthage College Campus. The 85-acre campus is outstanding with lakefront views and incredible architecture of buildings, including a new library, beautiful chapel, and physical education center. The college continues to be a genuine asset to the community. (Author's collection.)

GATEWAY TECHNICAL COLLEGE. Gateway Technical College specializes in opportunities for post-secondary occupational education. The first state-sponsored technical school in Kenosha opened in 1912, was known as the Vocational School; it provided an education for any child leaving grade or high school before the age of 16. In 1966, new state laws permitted vocational schools to become post-secondary schools, and by 1994, they were permitted to become technical colleges. The name "gateway" was adopted recognizing the inclusion of campuses in Kenosha, Racine, and Walworth counties. (Author's collection; courtesy of June Kuefler.)

UNIVERSITY OF WISCONSIN-PARKSIDE. The University of Wisconsin-Parkside evolved from being part of the University of Wisconsin Extension System. In the 1960s, a drive was conducted by a community committee of 100 people to locate a University of Wisconsin branch in the Kenosha area. The new campus immediately became a degree-granting institution. Pictured here is the Irvin G. Wylie Library–Learning Center. (Author's collection; courtesy of June Kuefler.)

UNIVERSITY OF WISCONSIN-PARKSIDE STUDENT UNION. The student union is one of the best buildings in the University of Wisconsin system. It includes a 400 seat cinema theater, bowling and recreation center, meeting rooms, spacious bazaar, dining and banquet facilities that seat more than 500, a small club and grill room, and the campus information center. (Author's collection; courtesy of June Kuefler.)

Three

Churches and Hospitals

Early settlers in Southport viewed both health and religion with a high regard. The condition of the body and soul were understood to be somewhat interrelated.

Outbreaks of disease were usually reflected among children, and homes were quarantined for diseases such as diphtheria, smallpox, and scarlet fever. In the early 20th century, it was necessary to close schools and factories because of serious outbreaks of scarlet fever, and before the schools reopened, the classrooms had to be fumigated.

Although initially limited to the business section, primitive sewage systems were created, and plans were made for continuing the project. Some schools had only one outhouse, patent medicines were advertised in the Kenosha newspapers, and bloodletting and leeches were common attempts by physicians to reduce fevers and restore health. The early 20th century also saw a campaign to stop spitting in public places.

Superintendent Mary Bradford mounted a campaign to kill flies because they were typhoid fever carriers. Children were rewarded for dead flies at the rate of 10¢ per 100 dead flies. The Merchants and Savings Bank provided 3,000 fly swatters and some prize money for the campaign. Although 82,500 dead flies were counted, the major benefit of such campaigns was to teach about disease carriers such as flies.

During World War I, a Spanish influenza outbreak caused the closing of many businesses, government offices, and schools. For several months, the death rate more than doubled. Many teachers volunteered to help keep places such as the post office operating. Society has come a long way since the days before hospitals and clinics opened and effective disease preventative programs began. As late as the 1950s, fear of infantile paralysis, also called polio, delayed the opening of schools and cancelled civic activities where crowds gathered.

Places of worship were established very early, and the earliest settlers were primarily Episcopalian, Methodist, Baptist, and Congregationalist. The Germans arrived slightly after the first waves of settlers from New York and New England came to the region. They brought with them the Catholic and Lutheran religions, and they were soon followed by Irish Catholics.

One of the earliest Irish Catholic priests in Kenosha, Fr. James Cleary, was the leader of the largest Catholic temperance movement in the United States, which helped greatly in the acceptance of the Irish immigrants.

The Methodists built the first church, completing it in 1842, as did the members of St. Matthew's Episcopal Church. The Congregationalists completed their church in 1844, and in 1845, the Catholics built St. James, initially named St. Marks. The Baptist church building was completed in 1849.

PARK AVENUE METHODIST-EPISCOPAL ORCHESTRA. This postcard from 1914 shows the Sunday school orchestra at the Methodist church. (Courtesy of Vern Kraus.)

THE HOLY ROSARY BAND. Quite typical of the spiritual leaders of all faiths, Fr. Angelo Simeoni of Holy Rosary Catholic Church was dedicated to helping his flock not only in spiritual matters, but to appreciate their new country and to become good Americans. He was well known among the families of Italian immigrants. He encouraged immigrants to get their citizenship papers and to be productive citizens. He arranged meetings of Italian women to meet American women through the Bain School PTA and to learn more about each other's cooking. Simeoni also had many talents, one of which was musicianship. He organized a band after teaching each of the boys how to play an instrument. He is seen here with the Holy Rosary Band in 1923. Second from the left in the third row is Julius Ventura, the last surviving member of this group. (Courtesy of Julie Ventura.)

METHODISTS WERE FIRST TO BUILD.
Building a church was not easily done in tough economic times, but the Methodists of Southport opened their first church in 1842. The church burned in 1883, but it was rebuilt. This real-photo postcard shows the second church that was built in 1907 and situated just north of the present First Congregational Church. The church was then known as the Park Avenue First Methodist-Episcopal Church. Meanwhile, German Methodists constructed their church, Immanuel Methodist Church, in 1890. (Author's Collection.)

PARK AVENUE METHODIST EPISCOPAL CHURCH. The largest Methodist congregation in Wisconsin sought a new, larger church, and in 1928, the group bought the Simmons home on Sixtieth Street and Sheridan Road. Mrs. Z. G. Simmons donated $50,000 in memory of her parents, the Emory Grants, for the building of the new church. (Author's collection.)

IMMANUEL GERMAN METHODIST CHURCH. As more and more immigrants settled in Kenosha, more churches representing a variety of denominations were built. The Immanuel German Methodist Church was built a block north of the courthouse on Sheridan Road in November 1890. This postcard was printed by a local printer and was the type where the back was reserved only for the addressee information. (Author's collection.)

CHRIST SCIENTIST. In addition to the larger denominations, Kenosha had several smaller groups with churches. The First Church of Christ Scientist was built in 1927, just west of the Simmons Library, and later became the site of Armitage Academy. Other smaller active groups included Bahais, Four-Square Gospel, and the Unitarians. (Author's collection.)

BAPTIST CHURCH. For some unspecified reason, the Baptists were slow to build and worshipped in a variety of places before building in the 1840s. Ann Quarles donated the lot at Fifty-ninth Street and Eighth Avenue. The building was finally competed in 1844. After help from Protestants and Catholics, the church was dedicated in 1849. The church burned in 1903, but it was rebuilt quickly. (Author's collection.)

CONGREGATIONAL CHURCH. The Congregationalists initially built on the north side of Pike Creek, and the church was moved over the ice, while Friedens Lutheran built on the vacated lot. Later, this building was erected. Michael Frank was among the early leaders who were Congregationalists. Although a member of the Congregational church, Frank attended other churches on a regular basis and showed respect for all faiths. (Author's collection.)

ST. MARKS CATHOLIC CHURCH. As the number of Irish immigrants increased, they were anxious to build a church. Bernard McLaughlin, the first Catholic settler in the area, allowed his home to be used for services by Father Bonduel from the Fond du Lac area and Fr. Martin Kundig from the Detroit area. By 1842, Kundig was assigned to the Milwaukee area and soon thereafter, St. Marks was built at the location of the present St. James. (Author's collection.)

ST. JAMES CATHOLIC CHURCH. These postcards show the third church built on the present site of St. James. The first was a wooden structure built in 1841, which was replaced by a brick structure in 1846. The present St. James church building was first used in 1884, and the congregation's centennial celebration took place in 1983. Meanwhile, several rectories, schools, and convents were built as the result of the parish's rapid growth. (Author's collection.)

ST. GEORGE CHURCH. The first German Catholic church was built in 1849, where St. Elizabeth Church stands today. It was described in an anniversary booklet as "Romanesque style, 125 feet long, 50 feet broad, and 40 feet high, with five windows on each side." The congregation numbered 30 families. On a very cold morning in January 1875, a fire destroyed the church, school, and sisters' house. The present building was built in 1876, and the number of families who were members of the parish had reached 500 by 1896. (Author's collection.)

ST. GEORGE CHURCH AND SCHOOL. The interesting 1906 message written on the front of this postcard may have referred to a wedding or other special event: "Remember this place at 2 o'clock June 4th 1906 Kenosha Wis Yours Truly K. N." (Author's collection.)

ST. MATTHEWS EPISCOPAL CHURCH. The Episcopalians have been in Kenosha from the very beginning, dedicating their first church on October 15, 1842. In constructing their first church building the men went into the woods to cut down and square the heavy timbers. That first and the second church buildings were located near the civic center and Sheridan Road. The present building was completed in 1890. (Author's collection.)

ST. NICHOLAS ORTHODOX CHURCH. In 1919, the St. Nicholas Russian Church was built. Prior to that time, some services were held at St. Matthew's Episcopal Church. Today, the St. Nicholas Orthodox Catholic Church, a parish of the Orthodox Church in America, is located at 4313 Eighteenth Avenue. This rendition of the beautiful church is by artist George Pollard. (Courtesy of St. Nicholas Parish.)

BETH HILLEL TEMPLE. Beth Hillel was built in 1925 on property purchased by the temple and the Young Men's Hebrew Association from E. Simmons. It is located on Eighth Avenue, at the northwest corner of Library Square. Kenosha also has a traditional synagogue, Bnai Zedek, located at 1602 Fifty-sixth Street. (Courtesy of Beth Hillel and Dena Feingold.)

BNAI ZEDEK. The cornerstone for the Bnai Zedek Synagogue was laid in 1911, and the dedication in 1912 was attended by more than 400 people. The small Jewish congregation worked for 12 years to develop plans and raise funds for the building. (Courtesy of Sid Leonard.)

ST. MARY'S LUTHERAN CHURCH. In 1871, Danish immigrant families invited Pastor Adam Dan of Racine to come to Kenosha to conduct services. In 1874, Dan agreed to help organize the congregation, which in 1876 took the name of St. Mary's Lutheran Church. He then became the first pastor. The second St. Mary's was located at Tenth Avenue and Fifty-second Street. This postcard shows the third St. Mary's at Sixty-fifth Street and Twenty-second Avenue. (Author's collection.)

THE NEW ST. MARY'S LUTHERAN. The parishioners of St. Mary's Lutheran Church increased rapidly over the years and operated for a long time with only one pastor. A venerable organist and choir director, Minnie Larsen served for 44 years at St. Mary's. In the 1920s, the use of the Danish language gave way to English. The new St. Mary's on Eightieth Street and Twentieth Avenue was dedicated in 1961. (Author's collection.)

OUR LADY OF THE HOLY ROSARY. Italian immigrant families founded Mount Carmel Catholic Church, which was located on Twenty-second Avenue, west of Columbus Park. Later, a group split off to form the Our Lady of the Holy Rosary parish. Part of the old church became a private residence, and a new Our Lady of Mount Carmel Church was built on the east end of Columbus Park. (Author's collection.)

ST. THERESE OF LISIEUX CATHOLIC CHURCH. As early as 1951, the Archdiocese of Milwaukee envisioned the need for another Catholic church on the south side of Kenosha and purchased 18 acres of land. After using the chapel at what is now St. Joseph's Home for the Aged, the St. Therese parish began to build a modern hexagonal church, hall, and school, which was dedicated in June 1959. (Author's collection.)

Ev. Luth. Friedens Kirche und Schule, Kenosha, Wis.

FRIEDENS GERMAN LUTHERAN CHURCH. The German Lutheran (Peace) Church was organized in 1856 with eight members. The congregation quickly outgrew the first small church, and a second church was built in 1883. Then, it was decided to move from the harbor area to the west side of the city. The church building was sold to St. Peter's Catholic Church. First a school was built, and then the third church was built in 1909. This postcard shows the church and school, which were built in 1909. (Author's collection.)

ST. JOSEPH'S HOME OF THE SACRED HEART, CARMELITE SISTERS, KENOSHA, WIS.

CARMELITE ORDER "OLD PEOPLE'S HOME." In 1919, the Carmelite Sisters built a 17-room home to take care of older citizens. The building on Sixty-first Street and Sheridan Road also had offices and a chapel. Shortly after, the same order of nuns established the St. Joseph Home for the Aged in South Kenosha. (Author's collection.)

ST. ANTHONY OF PADUA CHURCH. Around the beginning of the 20th century, most churches were founded by the various nationalities or immigrant groups. Slovaks who came from Austro-Hungary founded St. Anthony's in 1910. This is a photograph of the second and present building, which was dedicated during the economic depression in 1930. The parish has prospered spiritually and financially, despite facing heavy debt initially (Author's collection.)

ST. JOHN'S LUTHERAN CHURCH—Kenosha, Wis.—Rev. Paul Chropuvka, Pastor.
Architect— Hugo C. Haeuser, Milwaukee—Organ by ROESLER-HUNHOLZ, INC., Milwaukee

One of a Series Illustrating Modern Church and Organ Architecture

ST. JOHN'S LUTHERAN CHURCH. Founded by Slovak Lutheran immigrant families, this congregation purchased a beautiful small mansion that they renovated to create a church and minister's quarters. The former mansion of Colonel Hyde and home of Mary D. Bradford has been enlarged several times, and the congregation celebrated its 100th anniversary in 2005. This postcard was produced by an organ dealer who installed the organ at St. John's. (Author's collection.)

ST. THOMAS CATHOLIC CHURCH. In an era when virtually all churches had a tag designating them as Irish, German, Swedish, or Slovak, this church was English. St. Thomas has since been closed as part of a program involving staffing during an era of priest shortages. It was located on Sixty-third Street and Twenty-fifth Avenue. (Author's collection.)

GRACE LUTHERAN CHURCH. This Lutheran church was also an English church and was constructed in 1904. It has undergone several building renovations, and it continues to serve its people at 2006 Sixtieth Street. (Author's collection.)

WILLOWBROOK SANITARIUM. In the early 1900s, there were many individuals who contracted what was known as consumption or tuberculosis. This disease of the lungs was spread through bacteria usually contained in saliva. Spitting of saliva and tobacco juices was a common practice in saloons where spittoons or cuspidors were provided. Realizing how the disease was spread, ordinances were passed prohibiting spitting on the sidewalks. Sanatoriums such as Willowbrook were established to care for tuberculosis patients. (Author's collection.)

PENNOYER SANITARIUM. One of the earliest and largest sanitariums in Kenosha was the Pennoyer Water Cure. The Water Cure building and other buildings on the north side of the creek were devastated in a large fire in February 1890. The Pennoyers then purchased 40 acres on the north side along the lake and constructed the new Pennoyer Sanitarium. (Courtesy of Tom Hosmanek.)

ST. CATHERINE'S HOSPITAL. In 1917, the Sisters of St. Dominic purchased a large house on Sixtieth Street and Twenty-second Avenue and opened a small hospital. When more room was required, the sisters purchased the Pennoyer Sanitarium building in 1919. That became St. Catherine's Hospital, and a hospital association was formed to assist in the development of the institution. (Author's collection.)

ST. CATHERINE'S HOSPITAL. The old Pennoyer building was a frame structure, not fireproof, and it was not suited to house a modern hospital. A new St. Catherine's unit was constructed and dedicated in 1928 with impressive ceremonies. (Author's collection.)

ST. CATHERINE'S HOSPITAL. Before becoming a part of the United Hospital system, St. Catherine's had developed an extensive array of hospital services on its campus on the north end of Kenosha. This postcard shows most of the buildings that were demolished as a new campus was being developed on Highway 50 in Pleasant Prairie. (Courtesy of Dan Mack.)

AERIAL VIEW OF ST. CATHERINE'S HOSPITAL. Most citizens of Kenosha did not understand why it was necessary to move the St. Catherine's campus to the far west side of the Kenosha area, leaving only one hospital in the city. (Courtesy of Sid Leonard.)

KENOSHA HOSPITAL. In the 1890s, as Kenosha grew rapidly, there was a realization that hospital facilities were needed. Despite some funds being donated by the Simmons family, and several physicians offering their free service, the plans did not materialize. In 1903, a committee was formed to move the plans forward. A home and other buildings were purchased on Fifth Avenue and Sixty-first Street. That facility was quickly outgrown, and this building opened in 1911. (Author's collection.)

KENOSHA MEMORIAL HOSPITAL. For many years, Kenosha was a two-hospital city. Kenosha Hospital operated at 72 percent capacity with 315 patient beds, while St. Catherine's operated at nearly 90 percent capacity with 247 beds. A merger was considered, but it was postponed until competition arose from the building of hospital facilities by the Aurora Hospital chain in Western Kenosha. The two Kenosha hospitals merged and are known as United Hospitals. (Courtesy of Tom Hosmanek.)

KENOSHA MEDICAL CENTER CAMPUS. Kenosha Hospital grew steadily over the decades and now serves as the United Hospital Systems Kenosha Medical Center Campus. The excellent facilities include a pediatric unit affiliated with the Children's Hospital of Wisconsin. (Author's collection.)

Four

LIBRARIES AND PARKS

Col. John G. McMynn, principal of Kenosha High School from 1853 to 1859, noted in a speech that the "pioneers of Southport, of all nationalities, were not excelled in intelligence and culture by those of any section of the west. . . . The early settlers brought their books with them, and their love of learning gave a tone to their social life that would not suffer by comparison with that of the present day."

Kenosha's first circulating library was housed at the Unitarian church in 1872. A public library association formed in 1895, and the library was moved to a room above the First National Bank.

Since 1900, the Gilbert Simmons Library has been a source of civic pride for the people who live in Kenosha. In 1899, Zalmon G. Simmons offered to provide funding for the construction of a new library. Named after his son, Gilbert, who died at the age of 38, the library opened in 1900. The building was designed by Daniel Burnham, the architect responsible for the planning and construction of Chicago's 1893 World's Fair.

The generosity of Simmons was also experienced in many other ways, such as the soldier's monument in Library Park, the saving of Simmons Island for a notable park and swimming area, as well as numerous other civic projects.

Although the Gilbert Simmons Library is a jewel set in a six-acre park, other centers of the library system are also outstanding in many respects. These include the newly reconstructed Southwest Library, the Northside Library, and the Uptown Library. In addition, the system includes a bookmobile to serve outlying areas.

Another source of considerable pride in the Kenosha community are the 71 city parks. There are also some magnificent park and recreational developments in adjoining Pleasant Prairie, including America's largest municipal-owned recreation center located in Prairie Springs Park. The taxpayers of the county also maintain several excellent golf courses.

Kenosha has a 2,400 seat baseball stadium and a 3,500 seat football stadium, as well as two water parks. Nearby is the Bong State Recreation Area, 4,515 acres of rolling grassland, savanna, campgrounds, fishing ponds, solarium showcases, and 41.1 miles of trails for hiking, mountain biking, cross-country skiing, horseback riding, snowshoeing, and dirt bike riding. The area was slated to be a jet fighter air base named after Wisconsin born and America's foremost ace fighter pilot in World War II. In 1974, when the federal government's project was finally abandoned, the state of Wisconsin quickly bought the land.

FRONT VIEW OF LIBRARY, KENOSHA, WIS. LOUIS EWE, PRINTER. 4

GILBERT S. SIMMONS MEMORIAL LIBRARY. In 1906, it took this postcard just 28 hours to go by railroad post office from Kenosha to Holyoke, Massachusetts. The postage was a one-cent stamp. (Author's collection.)

GILBERT SIMMONS LIBRARY. The Simmons Library has an area of 9,045 square feet, including the basement area. It incorporates ornamentation and the classical style of the ancient Greek and Roman civilizations. Columns of limestone and marble, symmetrical public halls, a grand rotunda, large bronze entrance doors, and a dome extending 47 feet above the floor all combine to make the building a functional and beautiful service facility. (Author's collection.)

SIMMONS LIBRARY INTERIOR VIEW. Although the interior furnishings have been changed from time to time, the building itself has remained intact. The window motifs required more than 1,200 pieces of plate glass. The marble floor design adds to the classical beauty of the edifice. (Author's collection.)

MAIN FLOOR OF SIMMONS LIBRARY. Some of the features of the library show the furniture, lighting, and book stacks. This real-photo postcard was issued at a time when ladies dressed in the manner shown by the woman seen at the table in the foreground. (Author's collection.)

SIMMONS LIBRARY AND GROUNDS. This postcard was mailed in 1910 in Kenosha. It shows the library, as well as a monument commissioned by the donor, Z. G. Simmons. *Winged Victory* was created to honor the "brave men of Kenosha County who victoriously defended the Union on land and sea during the War of the Rebellion, 1861–1865." (Author's collection.)

WINGED VICTORY MONUMENT. Mailed in Kenosha in 1912 to a cousin in New York State, this postcard shows a closer view of the *Winged Victory* monument. Cousin Augusta, the sender of the postcard, suggested that her cousin, who had been ill, should take a trip for her health, adding, "Oh how glad I would be to see you now." (Author's collection.)

LIBRARY AND LINCOLN MONUMENT. The park where the library, the Lincoln, and *Winged Victory* monuments are located was a public common in the early days of the area's settlement. In 1909, a local citizen, Orla M. Calkins, offered to erect a bronze statue of Abraham Lincoln in Library Park. As plans for unveiling the statue were being completed, Calkins passed away. The unveiling took place as Calkins's body was carried past on the way to the cemetery. (Author's collection.)

WEST OF LIBRARY PARK. Chicago Street, now Eighth Avenue, was a street of elegant homes in 1909 when this postcard was sent. In the background is the First Congregational Church, which is located at the corner of Sixtieth Street and Eighth Avenue. (Author's collection.)

FRONT OF LIBRARY, LOOKING EAST. A child and two adults are shown strolling in front of the library and under an ill-looking tree in this card. The date of the postmark is 1914, and the records show that some trees in the city were dying about that time. St. Matthews Episcopal Church can be seen to the left. (Author's collection.)

TAYLOR GARDEN IN LINCOLN PARK. Named after a former parks director, Warren J. Taylor, the beautiful gardens in Lincoln Park attract many visitors and have been awarded recognition in many competitions. Since 1924, the flowering sunken gardens are an attraction all summer long. The area once known as Bond's Woods became Lincoln Park in 1914. During a portion of its existence, the park had a small zoo and a small arms range for shooting firearms. (Author's collection; courtesy of Timm Bundies.)

ALONG LAKE MICHIGAN. This view along the lake was taken when horse carriages were the more prevalent form of transportation for sightseeing. An interesting note is that this postcard was printed in Germany around 1908. (Author's collection.)

KENOSHA'S BATHING BEACH. Kenosha's beaches along Lake Michigan have always been immensely popular. In 1916, city officials were convinced better facilities, such as a bathhouse, were needed since as many as 8,000 residents flocked to the beaches on a hot day. Kenosha now has two huge public swimming pools, as well as Olympic-sized pools in two public high schools and a smaller pool in the third high school. (Author's collection.)

VIEW AT NORTH BATHING BEACH. Clothes worn at the beach did not become an issue in Kenosha until 1909, when men dared to go swimming with only swimming trunks, abandoning the one-piece tank suit that covered a man's chest. The city ordinances gradually accepted more abbreviated beach attire, but some older aldermen grumbled that girls over 16 should wear skirts over their bloomers on the beach. (Author's collection.)

CHANGING THE LAKEFRONT. The old World War I artillery piece disappeared from Eichelmann Park for several years, and inquisitive residents finally located it in a parks department warehouse. The huge Simmons factory that dominated the lakefront is also gone. The area today is devoted to a upscale housing project, a beautiful public museum, and a huge boat storage facility that serves as a reminder of past structures. (Author's collection.)

1988—View in Alford Park, Kenosha, Wisconsin

VIEW IN ALFORD PARK. This postcard was from Kenosha in 1946, and it shows Alford Park, which was named after a former civic benefactor and industrialist. Comprised of 80 acres, it now partially includes the outstanding lakefront Carthage College campus. Beach and picnic areas, sledding areas, and fishing spots are available in the park. (Author's collection.)

1996—Alford Park on the Shore of Lake Michigan, Kenosha, Wisconsin

ALFORD PARK ON LAKE MICHIGAN. Looking toward the lake from the vicinity of St. George Cemetery, the resting place of generations of residents, one can see the bridge on Sheridan Road. (Courtesy of Tom Hosmanek.)

BAIN PARK. This two acre city park, located in an older residential neighborhood a block west of the Kenosha Hospital, includes a playground and sandlot baseball diamond. The note on the back of the card from a visitor to Kenosha describes the city as a "lovely town." (Author's collection.)

DURKEE AVENUE. Durkee Avenue was renamed Third Avenue when all of the streets and avenues of the area were renamed in 1925. The postcard was sent in 1918 by Bill, a sailor on shore leave, most likely from the Great Lakes Naval Station located between Chicago and Kenosha. The card, which was addressed simply to "Miss" in Iowa, states: "Having a good time–Dry in a wet town." (Author's collection.)

PARK AVENUE VIEW. Park Avenue is now Eighth Street at Fifty-ninth Place, and it is still a very attractive residential area just east of the Simmons Library. Some of the vicinity is now a parking area for the YMCA. (Author's collection.)

GATES AT GREEN RIDGE CEMETERY. This historic burial ground began with several acres of land that was given to the city by Charles Durkee in 1839. Durkee's wife was buried there in 1839. Numerous prominent individuals are buried at the cemetery, including Michael Frank, John Bullen, and the Simmons family. (Author's collection.)

4844. Chicago Street, Kenosha, Wis.

CHICAGO STREET. Eighth Avenue was once called Chicago Street, and Kenosha's nickname was Park City. The street was paved during the 1920s, and since then, the traffic has increased to much more than the two automobiles shown here. (Author's collection.)

374. West Side Park, Kenosha, Wis.

WEST SIDE PARK. This park was once considered to be on the west side of the city, and it is now called Columbus Park. The far west end of the city was actually Thirty-ninth Avenue, known at the time as Grand View Avenue. Postmarked in 1913, this card was sent to Pennsylvania, and the sender commented on the topography of the area being "as level as a floor for miles & miles." Columbus Park is located at 2003 Fifty-fourth Street. Mount Carmel Catholic Church is located at the east end of the seven-acre park. (Author's collection.)

RUSTIC STAIRWAY. Many unique features such as this rustic stairway can be found in Petrifying Springs, also known as Petrified Springs. The park opened in 1928. Many of the early parks in the area with features such as this stairway were built by the Works Progress Administration (WPA), which provided work for Americans during the economic depression just prior to World War II. (Author's collection.)

PETRIFYING SPRINGS PARK. The Petrifying Springs Park area, is located at the north end of Kenosha, just west of the University of Wisconsin-Parkside. This was the site of an early settlement along the Jambeau Trail, which ran roughly along what is now Highway 31. An 18-hole county operated golf course, numerous picnic areas, sledding hills, a creek, and other recreational features characterize this 350-acre park. (Courtesy of Dan Mack.)

Five

CIVIC SERVICES, EVENTS, AND ORGANIZATIONS

Growth in communities such as Kenosha did not occur in a smooth, calculated fashion. It came in spurts and leaps and was affected by wars, economic conditions, and other factors.

One reliable barometer of the area's growth was the school population, and the consistent need for more classrooms, which began during the post–Civil War period and continued for more than a century.

In the time from the first settlement until the Civil War, the population of Kenosha grew to 3,968. A decade later, the population was 4,309, and in another decade it grew to 5,039. By 1890, when the growth accelerated rapidly, the population of the city was 6,532.

Beginning in 1890, the population began to grow more rapidly, and by 1900 the population in the community rose to 11,606–a remarkable 78.29 percent increase in one decade. Industry in the area grew as part of the larger industrial revolution. Greater opportunities existed for employment in urban factories, and there was less dependence for residents to make a living farming. As industries competed for workers, immigrants came to Kenosha in waves, often recruited by advertisements in foreign language newspapers and other means, which included active recruitment in Chicago and ports of entry from Europe.

A local newspaper, the *Telegraph-Courier,* commented: "Hardly a day passes that large numbers of foreigners do not arrive here. They find work in the different factories of the city, and, after a few years they build their homes here and become good American citizens."

Kenosha's growth was reflected in many ways, including the number of applications for citizenship, civic activities, and the need for services including water and sewer, transportation, fire and police protection, post office, and courthouse. A perspective on the times around the beginning of the 20th century can be gained by mention of facts such as telephones were still a luxury not shared by the general population, hospital services were needed, there was a 12 mile an hour speed limit for automobiles in the city, and automobiles were outnumbered by bicycles and horses. Kindergarten classes were initiated by the first superintendent of schools P. J. Zimmers, and the 1906 city directory reported that more than 300 buildings were constructed in Kenosha in the previous year.

Kenosha accepted the premise that a better city could result from objective planning, hopefully unhampered or only minimally directed by pecuniary and political interests. In 1922, Kenosha's newly installed city manager form of government retained the services of Harland Bartholomew and Associates to compile a city plan, which was adopted in 1925. This led to the Civic Center Park and numerous other improvements in planning city development.

VETERANS MEMORIAL FOUNTAIN. This memorial includes a large boulder shipped in from Naha, Okinawa, and sand from the beaches of Normandy. (Author's collection; courtesy of Edo Maccari.)

WORLD WAR I VETERANS. Kenosha was well represented in World War I, as many young men enlisted. This was also true in the Civil War, when the principal of the high school, several teachers, and all male students volunteered for service. In World War II and in subsequent wars, Kenosha has remained well represented. When the troops returned home, much celebration, including a parade, took place in 1919. Kenosha has also done a great deal of Red Cross work, sales of war bonds, and other activities to support the war effort. (Author's collection.)

PARADE OF WORLD WAR I VETERANS. World War I involved an intensive community effort filled with Red Cross activities, Liberty Loan drives, lightless nights, war industries, school war gardens, the recruitment of nurses, and drafting of soldiers. When peace came, a "wild day and wilder night," bedlam prevailed—it was orderly but noisy. On the order of the police, all saloons were closed. Local Italians took justifiable pride in having had 800 men in the Allied army. (Author's collection.)

COUNTY JAIL AND CITY HALL. This real-photo postcard of the old county jail and the first city hall was postmarked in 1909. Earlier, the city hall operated in rented quarters, as did the post office. The office of the first superintendent of schools, P. J. Zimmer, was in a rented room above a bank. (Author's collection.)

CITY HALL AND FIRE STATION. The fire station was built first, and the cornerstone for the new city hall was laid on September 5, 1910. The fire engine house was then resurfaced to match the new building. Firefighter Peter Pirsch formed a company to manufacture fire engines, and he donated an engine to the fire department. Kenosha quickly became the first motorized fire department in Wisconsin. (Author's collection.)

OLD CITY HALL AND FIRE STATION. Located at the southwest corner of Fifty-sixth Street and Eighth Avenue, the exterior of the old city hall looked quite imposing, even while the interior had disintegrated from use and the plumbing and heating systems became outdated, requiring replacement. After aldermen unsuccessfully tried to sell the building to the school district and to a senior citizen's group, the building was demolished, and the city offices moved to the old vocational school building.

EARLY PIRSCH-EQUIPPED FIRE TRUCK. Pictured in front of station No. 4 on Seventh Avenue is a new fire truck equipped by the Pirsch Company. At various times, the upstairs of this building was a classroom rented by the school district for overflow enrollment, and at other times it served as a place to play cribbage and shatzkopf among the firefighters and Father Nickel, the priest from St. George Church. (Courtesy of Sid Leonard.)

KENOSHA FIRE DEPARTMENT. Dated January 8, 1918, this postcard documents firefighters being pulled on a sled by two horses. The firefighters pose in front of a dance hall advertising dances "every Thursday Evening." Dance halls were popular following World War I, and minors were kept out of dance halls that were attached to bars. (Author's collection; courtesy of Bill Rice.)

PETTIT MALTING COMPANY FIRE. A memorable fire took place on March 17, 1914, when the Pettit Malt House caught fire and burned for several days. The malt house was never rebuilt, and the Elks Club was constructed on the site. (Courtesy of Sid Leonard.)

COURTHOUSE NO. 3. The first courthouse was constructed in 1850 when Kenosha separated from Racine County and the city name was changed from Southport to Kenosha. Twenty years later, the courthouse building was no longer adequate and a new building was constructed. This postcard shows courthouse No. 3, which was completed in 1885 and razed when the fourth and present county courthouse was built in 1925. (Courtesy of Judy Rossow.)

NEW KENOSHA COUNTY COURTHOUSE. Described as "Italian Renaissance architecture with the principal facade being an imposing colonnade of monolithic columns," the new courthouse and jail building was dedicated August 25, 1925. The courtrooms are appropriately decorated with murals, as is the main entrance hall that features Botticino marble, art glass ceiling, and hand-wrought iron work. The building was planned in anticipation of a large increase in population. (Author's collection.)

CIVIC CENTER LOOKING WEST. A portion of the civic center was located in the dominant area around which the Bartholomew Associates planned the development of the city. In the foreground is the rear of the new post office. The courthouse is to the right, and behind this is the new Moose Club, which later became the Union (Labor) building. The water tower in the background to the left is located at the edge of Columbus Park. (Author's collection.)

Post Office and Court House, Kenosha, Wis.

1920

THE OLD POST OFFICE AND COURTHOUSE. Pictured is the first federal building to serve as a post office in Kenosha. Prior to the construction of this post office, mail services were housed in rented quarters. Built in 1908 and renovated in 1934, a deal with the federal government gave the post office to Kenosha for one dollar with the stipulation that the 25-year-old building weighing 1,200 tons be removed from the site so that a new and larger post office could be built. The city manager saw the possibilities, and the old post office was inched a block west to become the new public museum. (Author's collection.)

1976— Historical and Art Museum, Kenosha, Wisconsin

"NEW" PUBLIC MUSEUM. This building, which was constructed to be a post office, soon became too small to accommodate the growing population. It was lifted with manual screw jacks off of its foundation, lowered on wheeled steel rails, and moved ever so carefully past the new building to its new location to serve as a Kenosha Public Museum. It took several weeks to rebuild a foundation and to lower the Beaux Arts building, and as this was being done during tough economic times, it took several years before the museum was finally opened to the public in 1937. (Author's collection.)

1599 POST OFFICE, KENOSHA, WISCONSIN

NEW POST OFFICE. Opened on August 26, 1933, the new post office, which faced Sheridan Road between Fifty-sixth and Fifty-seventh Street, was built large enough to serve the city's growing population. This building was located on the east end of the new civic center with the new courthouse on the north, the public museum on the west end, and the new Kenosha High School on the south. (Author's collection.)

OLD CITY OF KENOSHA POLICE BUILDING. Built in 1964, this police department building (and city jail) was quickly outgrown, serving the area for barely a decade. It now houses the administrative offices of the library system and the Kenosha Visitors and Convention Bureau. The police department and the county sheriff are housed in a new, much larger safety building. (Author's Collection.)

MAIN STREET, LOOKING NORTH. This *c.* 1908 postcard shows the Orpheum Theater on the right side of Main Street, while the old YMCA building can be seen on the left. (Courtesy of Tom Hosmanek.)

DANISH BROTHERHOOD HALL. Kenosha prides itself on having many nationalities and ethnic groups represented in the community. The Danes were among the immigrant groups arriving in Kenosha and nearby Racine shortly after the 1870s. Today, the Danish Brotherhood Lodge 14 is the largest DBA lodge in America, and the hall still stands as it was originally constructed in 1910. Among the leading members is Sir Robert Ibsen, who was knighted by the Danish king and queen. (Author's collection.)

SWEDISH SIGURD LODGE. The Swedish-American Club has a hall at 7002 Thirtieth Avenue. Kenosha's Centennial in 1935 featured a huge parade, and among the floats in the parade were these Vikings from the Sigurd Lodge. Centennial festivities included a pageant attended by 20,000 people at the Washington Bowl and a talk by Gov. Phillip LaFollette. (Author's collection.)

ITALIAN-AMERICAN SOCIETY. Pictured above is an early meeting of Kenosha's Italian-American Society. In 1903, some Italian immigrants formed the G. Garibaldi Society. As more Italian immigrants came to the Kenosha area, several other societies were also formed, including: St. Francesco, St. Michelle, and the Maria SS Della Schiava. In 1923, representatives from these groups met and founded the Italian-American Society to include all of the groups. (Courtesy of the Italian-American Society.)

ITALIAN-AMERICAN HOME. Led by a courageous and respected leader, Leonard Montemurro, the Italian-American Society decided to build a large clubhouse, meeting, and banquet hall. With great faith, many sacrifices, and only $8,000 in the treasury, the Italian-Americans of Kenosha undertook the challenge of building this $100,000 structure in 1925. (Courtesy of the Italian-American Society.)

ELKS CLUB. The Heritage House is located at the former Elks Club. For decades, the Elks Cub had the finest banquet hall in Kenosha, and it was the site of numerous civic activities. A spirited community campaign in the 1960s resulted in stopping discrimination and the rejection of new Elks Club members on the basis of race and religion. This building was constructed on the site of the former Pettit Malt House, which was destroyed by fire on March 17, 1914. (Author's collection.)

AMERICAN LEGION POST 21 BUILDING. The Post, organized in 1920, is named after a 19-year-old soldier, Pvt. Paul Herrick, who died at Pearl Harbor on December 7, 1941. The American Legion was a very active and influential civic organization, and for many years, it actively participated in many civic activities. One of the biggest challenges to the legion came in 1938, when a community-wide conflict took place over a proposal to have a Junior ROTC class at the high school. (Author's collection.)

YMCA BUILDING. The Young Men's Christian Association was active for a number of years, providing a reading room and other activities for young men. In 1904, the group erected a building at the corner of Sixth Avenue and Fifty-ninth Street on a lot just large enough to accommodate the building. The YMCA did a great deal to help immigrants learn the English language. (Author's collection.)

FLAT IRON AND YMCA BUILDINGS. The Flat Iron building is shown with an undertaker sign on this postcard postmarked in 1908. It was the first home of the *Kenosha Telegraph Courier* and later the *Kenosha Evening News*. The building has been used for a variety of business ventures and is still standing today. To the right is the YMCA building, which was sold in 1913 and converted into stores and apartments. (Courtesy of Tom Hosmanek.)

THE KENOSHA YOUTH FOUNDATION. Because there was criticism that the YMCA was "essentially a Protestant organization," in the 1920s, industrialist Charles Nash pledged $400,000 for a new building, if matched by residents and on the condition that the new building was open to those of all religious faiths. During World War II, the Kenosha Youth Foundation housed a USO Canteen that was open to servicemen and women. (Author's collection.)

MODERN WOODMEN OF AMERICA. Camps for the Modern Woodmen of America, a fraternal insurance, were seemingly everywhere, including Kenosha, Somers, and Pleasant Prairie. The woodmen camps provided social activity and insurance. This postcard was postmarked in Kenosha in 1908, and it features the national championship "Forester Team, Pike Woods Camp No. 391." The postcard shows the group in front of the Simmons Library. (Courtesy of Dan Mack.)

EAGLES CLUB. The Fraternal Order of Eagles built this clubhouse with a banquet hall, bar, dance hall, and bowling alleys. The building was designed by Kenosha architect Joseph Lindl and constructed in 1915 at a cost of $244,412. Lindl designed many of Kenosha's civic buildings. (Courtesy of John Sullivan.)

MAJESTIC THEATER. A matinee intermission provided the opportunity to have a photograph taken of those at the theater. The Majestic was one of 11 theaters operating in Kenosha in the 1920s. Many were closed during the Depression. (Courtesy of Sid Leonard.)

Six

COMMERCE AND INDUSTRY

For more than a century, industry and commerce have thrived in Kenosha. From the opening of the Bullen and Allen Store, the development of the harbor, and the coming of the railroads, to the opening and closing of huge factories such as American Motors, American Brass, Snap-On Tools, and McWhyte Wire Rope, Kenosha was sometimes been characterized as a lunch-bucket town. The opening of the large factory outlet mall just west of the city, the changes to the downtown retail business area, and the development of business and industrial parks have, of course, been reflected in the economic health of the area.

Less than a decade following the founding of the village of Southport, a pier was constructed with an appropriation by Congress, and as time went on, more imports and exports flowed through Kenosha Harbor. By 1855, the railroad was constructed with one link coming from Milwaukee and the other coming from Chicago.

The seeds of prosperity for the community were sown around the late 1800s and early 1900s as the result of the founding of industries such as the Allen Tannery, Bain Wagon Works, and the Simmons Mattress and Bedding Company, all of which were located in the harbor area. The Allen Tannery became the world's largest tannery, the Bain Company became the largest manufacturer of wagons at a time when the West was being settled, and Simmons became the world's largest manufacturer of bedding.

Other successful manufacturers include Cooper Underwear (now Jockey International), Frank L. Wells, Frost Company, McWhyte, Jeffery, Nash, American Motors, and Chrysler.

Bicycle manufacturing led to the development of Kenosha's largest industry–automobile manufacturing. Although highly beneficial to the community, the success of the manufacturers and the consequent growth severely strained the city's resources such as the schools, health services, water and sewer, police and fire protection, streets, and housing. Serious efforts to minimize problems and to plan ahead led to Kenosha being named the winner of Wisconsin's Better Cities award in 1925.

On several occasions since Kenosha developed, pessimists proclaimed the end of the prosperous community. During the Great Depression, Walter Winchell named Kenosha as a dying community, and when Chrysler bought and closed the American Motors company in 1985, some folks talked about the "last person out to turn off the lights." Rising from the ashes like a phoenix, Kenosha learns, adapts, and lives on, as prosperous as ever.

CITY SQUARE, 1923. The Kenosha area has overcome adversity many times and has regularly come back stronger than ever. (Author's collection.)

INDUSTRY AND COMMERCE DOMINATED HARBOR. As the industrial revolution made large-scale manufacturing important to the economy, the Kenosha lakefront was dominated by industry and commerce. Changing conditions, greater choices for transporting goods, and a greater emphasis on technology lessened the need for large factories sprawled out at the lakefront. (Author's collection.)

N. R. ALLEN & SON TANNERY. The Allen Tannery became the world's largest producer of leather for a great variety of products from harness to shoes. Loads of tree bark were brought in by boat and dumped along the shore. The tannery was founded in 1856 and was located in the area of the present Kenosha Municipal Building on Sixth Street and Fifty-second Street. (Author's collection.)

ALLEN TANNERY WORKERS. These workers at the Allen Tannery used the conventional vehicle for hauling in the days before trucks, the wheelbarrow. The employment of young boys, usually foreign boys who had just immigrated to the United States, was a common problem. Wave after wave of immigrants came to Kenosha during the late 1890s and early 1900s. (Author's collection; courtesy of Jake Turk.)

SIMCO BAND. In an age characterized by some as paternalistic, the Simmons Company and founders sponsored a popular band that played at numerous concerts and parades. The company also sponsored many athletic teams, including a spring camp to which the team was transported to get in shape for a season. The Simco Band posed for this photograph outside the Gilbert Simmons Memorial Library. (Author's collection.)

SIMMONS DOING BUSINESS. Before the regular use of telephones, postcards were used to set schedules of visits to furniture stores and warehouses. This real-photo postcard shows the vast industrial buildings of the Simmons Company, located on Kenosha's lakefront from the 1870s to the late 1950s. (Author's collection.)

CHICAGO-KENOSHA HOSIERY COMPANY. The Hosiery Company came to Kenosha and occupied the former Kenosha Watch Case Company in 1892. It quickly established a reputation as a manufacturer of popular brands of hosiery, including Black Cat Hosiery. The Cooper family operated this factory and the Kenosha Hosiery Company, which eventually became Cooper's, then Jockey Menswear, and subsequently Jockey International. (Author's collection.)

KENOSHA HOSIERY. This manufacturing plant became Cooper's, and it still houses the offices and some factory facilities for Jockey International, manufacturing both men's and women's hosiery, underwear, and sportswear. (Author's collection.)

AMERICAN BRASS COMPANY. This was the scene of an infamous 1919 robbery that led to the shooting death of patrolman Antonio Pingatore. Pingatore was the first member of the police department to die in the line of duty. The office building is all that remains of the once-thriving brass industry in Kenosha, and serves as the offices of *Happenings Magazine*. (Author's collection.)

JEFFERY'S AUTOMOBILE FACTORY. This postcard has two postmarks, one from Kenosha and another from Ashland, Kentucky, where it was received on October 11, 1905. Greetings in English and German appear on the front. The card was printed by Kenosha printer, Louis Ewe. The Jeffery plant started out as a bicycle manufacturing operation, expanding to Jeffery and Rambler Automobiles. It became the nucleus of Nash Motors. (Author's collection.)

KENOSHA WAS GROWING. The west side of Kenosha was relatively undeveloped at the time Jeffery began manufacturing operations. The Jeffery factory is seen on the left with the water tower and, at the time, only one smokestack. (Courtesy of Mary Ostermeyer and Joanne Wolf.)

THOMAS B. JEFFERY COMPANY. Manufacturing in Kenosha received a big boost when Thomas Jeffery began making Rambler bicycles in 1900. Two years later, the first Rambler automobile was built at the plant. The Jeffery plant grew rapidly and was sold to Charles Nash and his associates in 1916. (Author's collection.)

CHARLES NASH, "SELF-MADE MAN." Nash's parents separated when he was six, and he grew up teaching himself to read, write, and to do carpentry. He sold 80 sheep he had raised and bought a half share in a hay-cutting machine. Next, he stuffed cushions for a dollar a day. He rose to supervisor and then vice president. He joined Will Durant and Dave Buick in forming the Buick Motor Company. By 1908, he was Buick's president. In 1910, Nash was hired to straighten out General Motors. He did—without paying dividends to stockholders. He bought Jeffery's operation in 1916. (Author's collection.)

JEFFERY EMPLOYEES. The Jeffery factory and business grew rapidly as the business switched from bicycles, which were extremely popular in the early 1900s, to the manufacture of automobiles. Thomas Jeffery took a personal interest in the work being done, and he often worked alongside his employees. He also took an interest in the schools and donated much machinery and funds to make the new manual arts programs successful. (Courtesy of Sid Leonard.)

THE 1911 RAMBLER MODEL 64. The Jeffrey Company earned a reputation for making well styled, affordable automobiles. Nash continued a conservative policy of not making too many changes in styling from year to year. (Author's collection.)

NASH MOTORS COMPANY. Charles Nash set an example in working hard and was reputed to have never taken a vacation from the time he bought the Jeffery plant until 1925. He installed a light above his desk to signal any stoppage of the auto assembly line, which he would investigate immediately. Nash seemed to appreciate hard work, but initially he had a difficult time accepting unionization of his plant. (Author's collection.)

EMPLOYMENT FOR THOUSANDS. Charles Nash had a custom of walking around the plant and knowing most of the workers. About the time the workers unionized, Nash moved to California, where he spent most of the rest of his life, helping his ill wife. He passed away there in 1984 at the age of 84. (Author's collection.)

AERIAL VIEW OF NASH MOTORS. Under Charles Nash's leadership, characterized as a benevolent dictatorship, the company grew and prospered. The size of the plant can be seen on this postcard, which shows the full 28 acres. Nash built the one millionth vehicle in 1934, at which time the firm employed 4,500 workers. In 1936, a city-wide celebration honored Nash for making Kenosha an auto-making city. (Author's collection.)

NASH FOR 1934. This advertising postcard features the Nash for the year 1934, when it was also displayed at the Century of Progress Chicago World Fair. Nash was also featuring the LaFayette, a stylish sedan. (Author's collection; courtesy of Vince Ruffolo.)

This is the famous "Nash Tower of Value" at the World's Fair in Chicago. A building of plate glass with a high glass tower in which Nash Sixes and Eights keep moving up and down, up and down, day and night. A dazzling spectacle.

NASH TOWER AT WORLD'S FAIR. Chicago hosted the World's Fair, where the Nash Tower of Value was displayed. It was an endless chain of Nash cars moving up to the top and over, then going down again. The sparkling new automobiles were priced at $695 for the 75-horsepower Nash Six and the Nash 8s started at $830 and went as high as $2,055. (Courtesy of Vince Ruffolo.)

NASH AND AMERICAN MOTORS ADVERTISING. Postcards were one of the components of an annual campaign to interest potential buyers in Nash, LaFayette, and Rambler. A 1939 postcard used by most dealers advertised "a ride you'll never forget! . . . in that NEW NASH!" (Author's collection; courtesy of Vince Ruffolo.)

THE 1953 RAMBLER CONVERTIBLE. Nash executives were always looking for a niche that was unfilled by other auto manufacturers, and they were a bit late in entering the market with convertibles. This handsome convertible was among the last made by Nash. The following year, Nash merged with Hudson to continue manufacturing automobiles and a few trucks as American Motors. (Courtesy of Vince Ruffolo.)

THE 1954 NASH METROPOLITAN. Advertised as "today's only completely different car," the small sized Metropolitan attained 40 miles on a gallon of gas and had speeds up to 74 miles an hour. "Take a demonstration ride in this completely new kind of automobile and experience a new thrill in riding and driving pleasure," read the advertisements. (Courtesy of Vince Ruffolo.)

"THE BATHTUB NASH." Although Nash trucks, particularly the Nash Quad, served well during World War I and after, Nash automobiles always had some new and appealing features. After World War II, Nash built what was affectionately dubbed the 'bathtub." In 1947, a canary yellow Nash Ambassador was selected to be the pace car at the Indianapolis 500. It was the first time a closed car was accorded that honor. (Author's collection.)

AMERICAN MOTORS. Automobile manufacturing in Kenosha rambled on, and Nash Motors became Nash-Kelvinator, and then American Motors. At one time in the 1960s and 1970s, more than 16,000 men and women at American Motors were members of Local 72 of the United Auto Workers. Today, some 1,000 workers are employed at what is left of the operation, the Chrysler Engine Plant, where pride and quality are the joint aim of the union and management. (Author's collection.)

A MASSIVE BLAST. "A hole in the ground 300 feet long & 100 feet deep where the powder mill stood. Pleasant Prairie, Wis. 3/9/11," is what is inscribed on the face of this real-photo postcard. The Laflin-Rand (Hercules) Powder Company, which produced material for explosives, was always a hazardous operation. (Author's collection.)

SHATTERED BOX CAR. The explosion at the Laflin-Rand Powder Company shattered a railroad boxcar a half mile away. The cause of the explosion was never fully explained. Nine workers died, numerous buildings were damaged, masonry crumbled, and windows were shattered and cracked as far away as the Chicago area–45 miles away. All of the windows in the new Columbus School in Kenosha were shattered on the Roosevelt Road side. (Courtesy of Sid Leonard.)

PLEASANT PRAIRIE GENERAL STORE. The blast not only shattered windows; it also scattered metal beams and machinery over a wide area. An iron beam crashed through this building, which was occupied by the King family. (Courtesy of Judy Rossow.)

CHICAGO & NORTHWESTERN RAILROAD. The Chicago and Northwestern Railroad, now the Union Pacific Railroad, began in the early 1850s. On May 19, 1855, a line coming from Milwaukee and another coming from Chicago were connected in Kenosha. Note the "taxi" waiting. (Author's collection.)

CHICAGO & NORTHWESTERN TRAIN STATION. At the time the railroad was built, it was common practice to have the tracks and station at ground level. Over a period of years, some 35 persons were killed by trains, and many others lost limbs or were maimed in other respects. After considering the possibility of requiring the tracks to be elevated for decades, a car–train crash in 1928 resulting in the deaths of some well-known teenagers on a treasure hunt led to the eventual order to raise the tracks. (Author's collection.)

MILWAUKEE, RACINE, AND KENOSHA ELECTRIC RAILWAY. The Milwaukee, Racine, and Kenosha Electric Railway Company began running to the Kenosha city limits in 1897. In 1903, it connected to the Kenosha streetcar system at Seventh Avenue, near what was Pennoyer Sanitarium, later St. Catherine's Hospital, and now a housing project. The postcard shows the transfer point at the city limits. (Courtesy of Ron Frederickson.)

NORTH SHORE RAILWAY. One of the finest, safest, and fastest rides residents took to or from Milwaukee or Chicago was on the North Shore train. Running on the hour, the convenience, cost, and dependability seemed unmatched. Then, some investors purchased the railway, and by 1963, they had suspended the operation. (Author's collection.)

KENOSHA TROLLEYS, 1910. Looking northeast, two trolley cars at the corner of Sixth Avenue and Fifty-sixth Street are stopped to permit transfers. In the background is the First National Bank, now a part of the Chase chain of banks. The cars are marked with Kenosha Electric Railway Company. (Author's collection.)

KENOSHA TROLLEYS. On the right are two establishments that remained in this location until recent years–the Electric Light and Power Company and Becker's Cigar Store. The newspaper bike rack advertises the *Kenosha Telegraph*. The pump in the foreground is probably at the location of one of the old artesian wells in the city. (Author's collection.)

KENOSHA CAR AT THE NEW MUSEUM. A 1951 vintage electric streetcar runs to the new public museum, a natural history and art museum located on Kenosha's lakefront in the new Harbor Park area. (Author's collection; courtesy of Timm Bundies.)

TROLLEYS ARE BACK IN KENOSHA. Tourists find the new Kenosha trolleys interesting even though they travel in an oval of about two miles in distance. For 25¢, it is still a bargain ride from the railroad depot to the public museum, Harbor Park, and so on. (Author's collection; courtesy of John Bloner Jr., Earlene Frederick, and CoryAnn St. Marie-Carls.)

Seven
Retailers, Businesses, and Professions

Most communities develop in concentric circles, similar to the effect of a pebble dropped in the water with the circles spreading outward. Being situated on the shores of Lake Michigan, the circle of spread tends to be primarily away from the lake.

Retail merchandising and other forms of business often reflect the growth and vitality of a community. Many cities have experienced the change from a busy downtown area to malls, usually on the outskirts of the older community. Huge chain stores have replaced the smaller mom-and-pop stores. Similarly, the stability implied by customers knowing the proprietor, rather than wondering who the manager is this year, is also characteristic of changes taking place.

Kenosha once had a thriving downtown area where in the event of a parent retiring or passing on, a relative would take over. For years people patronized a shoe store or department store where they knew the manager; a family-owned drugstore that specialized in being a pharmacy; a clothing store where the owner was actually seen and would usually see that customers got a good fit.

Similarly, professional people such as physicians, lawyers, dentists, clergy, and others tended to select a community and stay there. Oftentimes, it was the community in which they were born.

Kenosha merchants attempted to save the downtown area by creating a pedestrian mall, and ultimately they had to concede that the "times they are a-changing." Currently, a further attempt is being made to revitalize business in the downtown area, and with new residential areas being developed nearby, there is the possibility of seeing the once bustling downtown return.

Change is inevitable, and most business people are well aware of that. But, perhaps it takes more adjusting to having the local bank change its name, ownership, and management more than twice in a decade.

Kenosha still has some businesses that were here 50, 75, and 100 years ago, and many families also. Yet, there is no question that as Kenosha has changed from being a factory town to inching closer and closer to becoming a bedroom community, businesses will change also.

People change with the times, learning from history all along. They change their attitudes, skills, and knowledge. People also tend to forget some of the difficulties along the way, so let us look in on Kenosha's past and current businesses—what has lasted and what has not.

FILL THE BIN TIME. McNeil Fuel Company was well known in Kenosha. They delivered many tons of coal direct to coal bins, which were found in every basement. This is one feature from the past that no one seems to miss. (Author's collection.)

MAIN STREET. Main Street became Sixth avenue but remained a main street. Seen in this view is a drug store, dentist's office, clothing store, hotels, and other establishments in the center of Kenosha—at that time. (Author's collection.)

MAIN STREET, LOOKING SOUTH. Generally, this is the same area shown on the postcard at the top of the page, but looking in the opposite direction. Progress was being made as is shown by the street paved with brick. (Author's collection.)

MAIN STREET, 1910. The street surface still consisted of paving brick with two sets of streetcar tracks located in the center in this image. One-cent stamps were still being used to send cards, and it is likely that the view is of Main Street around 1910. Businesses on the right side of the street include People's Credit, Chop Suey, Graham Cafe, and Majestic Theater. Seen on the west side is Heyman's. (Author's collection.)

MONEY GROWS ON TREES? This postcard mailed in 1909 shows a tree with money hanging from its branches and telling the benefits of saving. The calendar is for September 1909. The First National Bank, established in 1854, sent out these cards. (Courtesy of Dan Mack.)

SIXTH AVENUE, LOOKING SOUTH. Decades later, not only were the automobiles looking more modern, but so were the store fronts. Also apparent is the presence of chain stores such as Woolworth's, Kresge's, and Walgreen's. On the left, note that the Schmitt Brothers drinking establishment was located on Sixth Avenue next to the Florsheim shoe store at this time. (Author's collection.)

SCHMITT BROTHER'S TAVERN. Sheriff Bill Schmitt and his brother always operated a respectable place. The beautiful wooden back bar was fairly typical of better establishments that dispensed soft drinks and other beverages. Spittoons or cuspidors were common in such places, as was pipe and cigar smoking and the chewing of such products as Eight Brothers or Plow Boy. (Author's collection.)

"DON'T MONKEY WITH YOUR CAR." Not all business was located on Sixth Avenue. An ink-blotter advertisement for the Sheridan Road Garage gave advice to potential customers. The date can be assumed from the phone number, 6181, since that preceded exchanges such as Olympic and divisions such as 652, 654, and 658 in Kenosha, and note that Nash cars were being sold and serviced. (Author's collection.)

118

MAIN STREET. Shoppers were still using a horse and buggy to go downtown in Kenosha at the time this *c.* 1905 photograph was taken, but no automobiles. There are trolley tracks and wires in great abundance, making the photograph look as if it was systematically scratched. Some familiar names are Barden's, on the left, and Eichelmann's, on the right. (Author's collection.)

SOUTHPORT MALL. When more and more of the retail business was being done by stores at the factory outlet mall, west of the city, some downtown merchants joined the flow westward. Other merchants and city officials tried a pedestrian mall along Sixth Avenue. After several years, it was admitted that it sounded like a good idea, but the end result was not successful, so the mall came down. (Author's collection; courtesy of June Kuefler.)

KENOSHA THEATER. This movie house was built in 1928, but it did not survive the hard economic times. The marquee announces Bebe Daniels, in *Swim, Girl, Swim*. The postcard was postmarked in October 1928 in Kenosha, and it is written to Elsa from Herman, who indicates this is his third card in three days and suggests it is time for a letter from Elsa. (Author's collection.)

THE OLD RHODE OPERA HOUSE AND HOTEL FISCHER. The Rhode was used for many community events. After the Kenosha High School (the Annex) third floor auditorium was declared unsafe, many school events, including graduations were held here. Saxe Amusement Company purchased the Rhode in 1925, wrecked the building, and built the half-million dollar Gateway Theater. The Hotel Fischer is to the right of the theater. (Courtesy of Sid Leonard.)

GRANT HOTEL. This hotel building was constructed in 1875. The owner, Levi Grant, came to Kenosha in 1856 after living in Bristol for 20 years. The Grant House stood on the northeast corner of Fifty-eighth Street (Wisconsin Avenue) and Main Street (Sixth Avenue). In 1903, it was purchased and renamed the Eichelman Hotel. The hotel was razed in 1922, and the Schwartz Building was built on the site. (Author's collection.)

DAYTON HOTEL. The hotel was built in 1925 with a fine dining room, coffee shop, lobby, and 100 guest rooms. The motto of the hotel was "Rest Assured." A new owner converted the hotel to a nursing facility for veterans with disabilities incurred while in military service. (Author's collection.)

THE JOHNSON-HANSEN COMPANY. Located at Fifty-ninth Street and Seventh Avenue, this building housed a clothing store and the Pratis shoe store. The Kaelber-Kraft Plumbing and Heating Company is located to the right. (Courtesy of Sid Leonard.)

DELTA DRIVE INN. A favorite restaurant of many Kenosha residents, the Delta Drive Inn was located just north of the old St. Catherine's Hospital at the junction of Sheridan Road and Seventh Avenue. (Author's collection.)

122

RADIGAN'S RESTAURANT. Radigan's attracts diners from a large area, and it has an excellent reputation as a restaurant. Opened in 1933, it is still operated by the Radigan family. The restaurant is located in Pleasant Prairie, three miles south of Kenosha and a mile north of the Illinois–Wisconsin state line on Sheridan Road. (Author's collection.)

WILMOT STAGE STOP. Located in Wilmot on Highway C, west of Kenosha, is the historic Wilmot Stage Stop. This restaurant has been in continuous operation since 1848, and the old travelers' sleeping rooms are still intact in the attic area. (Author's collection.)

UKE'S MOTORCYCLES. Perhaps inspired by the Nash Tower at the Chicago World Fair, the Ulicki's new building, located west of Kenosha on Highway I-94, features a tower displaying historic Harley-Davidson motorcycles. Founded in 1930, this postcard states that Uke's is "the oldest Wisconsin dealership with the tallest motorcycle tower in the world." (Author's collection.)

TRAILER PARK AND CABIN COURT. Following World War II, when automobiles were again available, cabins had a lively business along highways such as Highway 42 (now 32) in the stretch of road between Racine and Kenosha, and on Highway 41 (now I-94) between Milwaukee and Chicago. (Author's collection.)

TURNER'S TULIP GARDEN. Lewis Turner and his family had a floral shop in the old Flat Iron Building across from Library Park. For many years, they displayed flowering tulips in May at their farm near the present Palmen Motors on Highway 50. (Courtesy of Sid Leonard.)

MIDWAY MOTOR LODGE. Located at 1800 Sixtieth Street, the Midway Motor Lodge featured 91 air-conditioned rooms, an indoor pool, television, and convention and banquet facilities. The lodge was in operation barely three decades, and it has since been demolished. (Author's collection.)

WEBB'S CHEESE MARKET. It is difficult to leave Wisconsin without taking some great-tasting cheese with you. Webb's is no longer on "the junction of Highways 41 and 50," but the area is thriving selling not only cheese, but fast food, good food, and a great deal of factory outlet merchandise. (Author's collection.)

MARS CHEESE CASTLE
2800 - 120th Avenue
Kenosha, Wisconsin 53144
Phone (262) 859-2244

Mars Cheese Castle. The cheese castle has sold cheese to thousands of visitors since it was founded by Mario Ventura Sr. in 1947. At one time it also had a gas service station and a motel attached. The story is told of Ventura's portrait being painted by a Marine veteran starting his career in portrait painting. When an out-of-state insurance executive stopped to get some cheese, he was impressed with the quality of the portrait, had his own done, and helped launch the career of internationally-acclaimed artist George Pollard. Pollard has since painted Pope John Paul II, John F. Kennedy, and numerous other government officials and prominent people. A gallery featuring the Pollard family's artwork is located at the old Rhode Opera House in downtown Kenosha. (Author's collection.)

Kenosha, Wis. Downtown on The Lake

DOWNTOWN ON THE LAKE. This view of the Holiday Inn shows Simmons Island and the harbor where Kenosha's history began. (Author's collection.)

With Kindest Regards

To hold all I have
to say
Would take a good many cards
But I'll only send
one, to-day,
With Love and Kindest Regards.

WITH KINDEST REGARDS. Many a sentiment has been expressed on postcards over the years. Some of the fanciest Christmas, Easter, anniversary, and congratulations cards have been sent and received. Some collectors specialize in cards by subjects or topics, others collect only cards that are photographs or advertisements. Most of the cards in this book show historical Kenosha and Pleasant Prairie. These are presented "with kindest regards."